The Book in the Cathedral

CHRISTOPHER
DE HAMEL

The Book in the Cathedral

The Last Relic of Thomas Becket

ALLEN LANE
an imprint of
PENGUIN BOOKS

ALLEN LANE

UK | USA | Canada | Ireland | Australia
India | New Zealand | South Africa

Allen Lane is part of the Penguin Random House group of companies
whose addresses can be found at global.penguinrandomhouse.com

First published 2020

003

Copyright © Christopher de Hamel, 2020

The moral right of the author has been asserted

Set in 11/14.75 pt Sabon LT Std
Typeset by Jouve (UK), Milton Keynes
Printed in Great Britain by Clays Ltd, Elcograf S.p.A.

A CIP catalogue record for this book is available from the British Library

ISBN: 978-0-241-46958-3

www.greenpenguin.co.uk

Contents

The Book in the Cathedral

An archimandrite once explained religious relics to me, as he was driving his very old car through the Troodos mountains. A saint chosen by God is assumed to be constantly filled with the Holy Ghost, he said. Every physical part of the favoured servant of God would therefore be divinely saturated from Heaven, even the clothes on the body. When the saint dies, the archimandrite assured me, this intense holy presence would not necessarily evaporate, but would linger on in some way where it had been so profoundly infused during the saint's lifetime. Surviving body parts and clothes of a dead saint would therefore retain a residue of supernatural and efficacious essence, he said, and devotion at a saint's tomb or reliquary brings the pilgrim into almost tangible proximity to actual godly presence still on Earth.

Relics of important saints were immensely valuable in the Christian Middle Ages. Access even to traces of the Holy Spirit might work great wonders in an age of danger and negligible medicine. After the murder of Archbishop Thomas Becket in Canterbury Cathedral on 29 December 1170, some small pieces of his bones and blood-stained clothing were carefully distributed and were often enclosed in beautiful enamel reliquaries commemorating the martyrdom of the new saint (Plate 1). Miracles were reported within a week of his death. The speed of Becket's canonization only three years after he died allowed opportunities to preserve many of his personal effects as relics. What remained of Becket's murdered body in Canterbury was gathered up into one of the most popular and profitable shrines in Christendom, dedicated in 1220. The desire to be close to these relics of the saint brought pilgrims to the cathedral in huge numbers, reportedly up to 100,000 a time for major festivals, including the fictional narrators in Chaucer's fourteenth-century *Canterbury Tales*. It was a vast industry, both spiritually and commercially.

By the end of the medieval period, not everyone was as impressed by relics as my archimandrite. The Christian humanists Erasmus and his friend John Colet, dean of St Paul's, visited Becket's shrine in 1512. They were unmoved by some of the treasures which the courteous prior of Canterbury kindly showed them: bones and reputed samples of Becket's clothing were passed

to them to hold and kiss, and a scrap of a dirty hand-kerchief soiled (Erasmus reported fastidiously) by the sweat of the saint's neck and the running of his nose. At the Reformation soon afterwards, such distasteful relics became an easy target for puritanical outrage. They were regarded as superstitious idolatry. Across Protestant parts of Europe, supposed pieces of saints were abominated and were destroyed with frenzied right-eousness. The shrine of Thomas Becket was stripped of its gold and then utterly demolished in September 1538, and (despite lingering conspiracy theories) any rem-nants of the saint's bones were almost certainly burnt. All that survives in Canterbury now is an empty pave-ment behind the high altar.

For much of the last 500 years in England, religious relics have been widely ridiculed as an aspect of the credulity of the unreformed Middle Ages. Their lowest point was probably during the Enlightenment in the later eighteenth century. It is curious that at just that moment, for the first time, there began a new fashion for secular relics. People began to treasure little sou-venirs of celebrities, like those made from original wood of Shakespeare's mulberry tree (cut down *c.* 1756) or Nelson's *Victory* (1805), and locks of hair of famous people such as Mozart (d. 1791) or Lord Byron (d. 1824). Premature death was an attraction (also Keats, Shelley, Lincoln and others). Relics of Napoleon and Wellington are legion. The collecting of autographs,

too, is a kind of mania for relics, usually traced in England back to the late eighteenth century and especially to the drawing rooms of the 1800s, when small clipped signatures pasted into albums provided direct physical links to great heroes of the past. As an experience, this is not so different from the frisson of actually touching a tiny piece of Becket's hair shirt.

Today, rock stars and footballers still generate memorabilia preserved by their devotees, but (fortunately for them) this does not usually include body parts. Popular novelists in our time are not subjected to relentless requests for hair clippings, as the Brontë sisters or Jane Austen were. Nowadays, we justify the fairly basic human instinct for such connections with an intellectual gloss. Collectors usually tell you that they prefer to venerate autographs in historical context, rather than as isolated signatures. The taste is for whole manuscripts, sustained working papers and significant correspondences, documenting the evolution of some great cultural achievement or scientific advance. The shrine to the Beatles in the British Library displays manuscript drafts of their songs, and it attracts an almost permanent arc of worshippers. It is striking what emphasis we now give to the written word among desirable relics of the past. If we had (say) a tooth of William Shakespeare or one of his shoes, it would have a certain mild interest, if its authenticity was provable, but its value would be finite. What we would really want now is a book

from Shakespeare's library (no undisputed examples are known), for that would be a window into the mind and learning of the man, especially if it showed signs of use by him and the workings of his thoughts. Much effort has therefore been spent in trying to identify texts that must have been known to historical figures such as Bede, King Alfred or Chaucer. Surviving books once owned and read by great figures of the past have for us an interest and importance quite as intense today as an original bone of a saint would have had for our ancestors in the Middle Ages.

In the case of Thomas Becket, we know an enormous amount about his life, but very little about his mind or spiritual development. He is probably the best-documented and most famous non-royal person of medieval England, but his intimate personality is always somehow just out of sight. His letters (and there are many) were written by other people in his name. His conversations were reported after his death by disciples with an agenda. His motivations are sometimes unexpected or unguessable. We do not know what Thomas Becket thought about alone in the secret hours of the night, or where he stood privately on matters of faith and sanctity. Apart from the indisputable martyrdom, we do not even really know whether he was a saintly man, as Gregory the Great and Anselm undoubtedly were. The mystery of Becket's mind is what makes his story such an enduring topic of speculative literature,

from the metrical romances of the end of the twelfth
century through to Alfred Tennyson (1884), T. S. Eliot
(1935), Jean Anouilh (1959) and others.

The basic narrative is familiar. Thomas Becket was
born in London around 1118–19 into a Norman mer-
chant family. For an unknown period he attended
the early cathedral schools of Paris. He entered the
household of Theobald of Bec, archbishop of Canter-
bury 1139–61, who sent him to learn canon law in
Bologna and Auxerre and later recommended him to
Henry II in 1154–5 as chancellor of England. Becket's
new close friendship with the volatile young king ben-
efited them both, materially and personally. In 1162,
Henry appointed his chancellor to the archbishopric on
Theobald's death, in the expectation that Becket would
hold both offices simultaneously and bring the Church
into line with the king's understanding of royal auth-
ority. As can happen when a person has been a protégé of
a great man who has raised him to new heights, Becket
came to resent his patron, who in turn felt betrayed by
his former dependent's ingratitude. It is an old drama,
and a very human one. The new archbishop resigned
the chancellorship and threw himself wilfully into con-
flict with the king over the rights of the clergy. He was
forced into exile in France in 1164. Six years of stub-
born arguments did little credit to either protagonist. In
early December 1170, on a half promise of a settlement,
Becket returned to England. He provoked the king one

more time, and Henry II is reported to have lost his temper. Four royal knights stormed into Canterbury on 29 December and followed Becket into the cathedral, where they struck him dead. Within three years he was the most famous modern saint in Europe, and his remains and his clothes had become relics.

There are a number of contemporary references to the books which belonged to Thomas Becket, and several of them still survive. Many were collected by Becket during his exile in France in 1164–70. He was accompanied at that period by a circle of advisers, or *eruditi*, including Herbert of Bosham, former pupil of the theologian Peter Lombard in Paris, who attempted to instruct the former chancellor in the religious literature appropriate to an archbishop. John of Salisbury, classical scholar, stayed mostly in Rheims with Peter, abbot of Celle, but largely acted as Becket's secretary-in-exile. Herbert had an especially high opinion of the library of the Cistercian abbey of Pontigny in Burgundy, south of Rheims, later describing it as a rich intellectual pastureland where he and Becket had studied together. An inventory of the library of Pontigny Abbey at almost exactly this date records some 270 manuscripts, which were both up to date and impressively comprehensive. Becket and his banished companions were guests at Pontigny in 1165–6. While there, Becket threw himself so vigorously into the privations of Cistercian discipline and asceticism that Herbert of Bosham seriously

worried for his health. His clerk and later biographer William FitzStephen describes how the archbishop immersed himself in learning at Pontigny and began to have manuscripts copied for himself, and he recounts that, whenever Becket heard of a text anywhere in France of sufficient antiquity or approved authority, he would have it transcribed to enrich the eventual collection at Canterbury. This was a conventional pastoral duty of a medieval bishop. Becket would have been familiar with the life of William of Saint-Calais, bishop of Durham eighty years earlier, who during his own exile in France in 1088–91 had also commissioned manuscripts that he later brought home to his cathedral, where they had been received with acclaim. Becket's 'approved authority' probably principally meant the advice of his attendant *eruditi*, Herbert of Bosham and John of Salisbury.

Shortly before the martyrdom, this collection of books was transported back to England. The chronicler William of Canterbury tells us that this was a last-minute decision. He records that when Becket was on the coast to the south of Calais waiting for a favourable wind to cross the Channel around the beginning of December 1170, he decided that the books might endear him to the monks of Canterbury. In a sentence of syntactical complexity in Latin (and not much clearer in English) he quotes Becket as saying, 'As for my library, I had decided to leave it in the meantime on this side of the

sea, but I am compelled by the vagaries of circumstance to bring it with me, so that, if I am not recommended by my past services' – he is referring to his uncertain reception by the monks on arrival – 'the possessor [of such books, that is, himself] may be more favourably received for burial owing to what he possessed.' If this is reported accurately, Becket already suspected that his death might be imminent, and he hoped that the monks would at least approve of him because it would be accompanied by a bequest of interesting books.

In the event, this strategy had no effect. The monks seemed very indifferent to the manuscripts once owned by Becket. Even as they were gleefully hoarding the martyr's clothes and distributing his relics, they sent the books over to the priory's library to join the general reference collection of the community. Mainly for convenience of classification rather than piety, acquisitions at Canterbury, as in many monasteries, were listed under the names of their donors. Herbert of Bosham, for example, eventually gave five books, shelved together under his name. A hundred and fifty years after Becket's death, the entire library of the cathedral priory was inventoried at the initiative of Henry of Eastry, the prior who died in 1331 (Plate 3). The 'books of Saint Thomas', as they were called, were then kept in the first bay of what was probably the second side of the slype, the passage-way off the southeast corner of the cloister. (The space is still a storeroom

where the vergers now keep their bicycles and the gardeners their watering-cans.) The list may not be entirely comprehensive, for there might have been strays from the original bequest in the intervening years or some books might have been slipped in by mistake, but it is nevertheless an engrossing and little-studied record of Becket's personal collection. It has been printed several times, most recently in 1903, when the entire book catalogue of Canterbury was edited by M. R. James, medievalist of Cambridge and Eton still remembered for his ghost stories.

The study of history is often licensed impertinence. We would never dare rummage through a rich man's closets today or rifle through his papers without permission, but transfer the temerity to the Middle Ages and it is considered to be research. Reading the inventories of the fourteenth-century cathedral priory has a thrill that still feels slightly presumptuous and voyeuristic. We all know what a lot you can tell about any person by looking at the books they own, even now, and the inventory almost allows us the experience of standing in the slype and pulling Becket's books off the shelves one by one.

There were about seventy-five manuscripts. The approximation is necessary because medieval books often comprised several texts bound up together. The cataloguer at Canterbury listed the first title and then sometimes added in red, '*In hoc volumine continentur . . .*' – 'In this volume is contained . . .' – followed

by another text, but then it is not always clear whether the next listed after that was now a new book or a further component of the previous one. M. R. James made editorial decisions, not always rightly, I think. Medieval books have no title-pages. Sometimes the cataloguer had no real idea what a text was, or copied its opening words without properly understanding them. Not every title owned by Becket is conclusively identifiable. I cannot pretend that it would necessarily have been different if we had actually been there in the slype with the manuscripts. Despite all caution, however, here is a unique glimpse of the great man.

As one might expect, there are a number of recent Cistercian texts listed, consistent with a collection of books begun when the patron and his advisers were staying at the well-equipped Cistercian abbey of Pontigny. These include a composite volume of works by Saint Bernard of Clairvaux himself (1090–1153), principal pioneer of the Cistercian Order. There are two manuscripts of sermons, listed successively as those of Peter of Ravenna and of Guerric of Igny, a Cistercian abbot who died in 1157: exactly these texts in the same order are listed in the Pontigny library catalogue as adjacent volumes, and presumably those provided Becket's exemplars. There is a volume described as '*Liber Odonis prioris de moribus ecclesie*', 'The book of Odo the prior on the customs of the Church'. The author, who died in 1161, was prior of the Cistercian abbey of

Morimond in eastern France, about a hundred miles from Pontigny. The text, which is uncommon, is actually on number symbolism, usually called the *Liber de Analyticis Ternarii*. By happy chance, Becket's manuscript still survives (Plate 4). It was one of the books salvaged from the residue of the medieval library of Canterbury and given to Trinity College, Cambridge, by John Whitgift, archbishop of Canterbury 1583–1604 and former master of Trinity. Along the extreme top of the opening page, just decipherable if you turn the book back and forth against the light, is an erased medieval inscription almost identical with the mistaken wording of the fourteenth-century inventory: '*Liber oddonis prioris de moribus ecclesie sancti Thome archiepiscopi*', recording the title as they thought it was and then matter-of-factly that this was the copy of Saint Thomas the archbishop, not even 'martyr'. A later hand from the time of the Reformation adds '*deleatur iste titulus*' – 'This title should be deleted'. The manuscript is utterly Cistercian. The Order was famous for its graceful but austere pale architecture and its manuscripts with their prescribed monochrome initials without use of gold. The large opening initial 'V' on folio 3r here could not be anything but Cistercian, formed of scrolling leaves and interlace in deep red and no other colour. Elsewhere, the volume has simple initials in red or blue, rarely together and never with use of images or gold. There is no question that

this manuscript was made anywhere but in a Cistercian scriptorium.

There are notable classical texts on Becket's booklist. From what we know of the archbishop, he was not particularly interested in the literature of antiquity or even an especially fluent Latinist at all. These books must represent recommendations made for him by his attentive adviser John of Salisbury, one of the most profound classicists of the 'Romanesque' age. John may not have hoped that Thomas Becket would necessarily read them but that copies would at least reach the library of Canterbury at the archbishop's expense. The inventory includes Cicero's *Tusculan disputations*, a Livy in two volumes, the *Attic Nights* of Aulus Gellius, two copies of Vegetius on military strategy, Solinus on the wonders of the world bound up with a copy of Valerius Maximus on famous people, the letters collected by Cassiodorus, copies of Priscian, Martianus Capella, Quintilian and Seneca, and the poems of Martial. Some texts might have been found locally in Pontigny, where the abbey's twelfth-century library catalogue includes Solinus similarly bound with Valerius Maximus, as on Becket's list; it might easily have been the exemplar. John of Salisbury himself owned a manuscript of Valerius Maximus too, which he later bequeathed to Chartres Cathedral. The library at Pontigny also had the letter collection of Cassiodorus, which might have provided a convenient model. Becket's copy survives,

and is now at Magdalen College in Oxford. The Canterbury booklist calls it 'Letters of the king of the Athenians' because the text opens with correspondence by King Theoderic, and this same misleading title is copied word-for-word on to the manuscript's opening page. It is a plain little book with simple initials in red, not as obviously Cistercian as the Odo of Morimond but quite plausibly obtained at Pontigny.

We must assume that the writings of other classical authors were among those which William FitzStephen had described as being texts 'of sufficient antiquity', sourced for Becket all over France by John of Salisbury. Livy was scarce in the twelfth century, and John must have been glad to locate a manuscript for copying. He had quoted Livy in his political treatise the *Polycraticus* (c. 1159) but probably only indirectly, from the later epitome of Roman history by Florus. What is almost certainly the second volume of Becket's set of Livy is, like the Odo, now also in the library of Trinity College, Cambridge, by the bequest of Archbishop Whitgift. It is a large and elegant book, with coloured decoration resembling that of manuscripts made in the region of Champagne. Although they are of course contemporary texts, Becket's copies of John of Salisbury's own *Polycraticus* and his *Metalogicon*, on philosophy, were doubtless urged upon him by the author: there they are together in a single volume as the final item in Becket's booklist. This manuscript is now in the Parker Library

in Cambridge, among the books salvaged by Matthew Parker from Canterbury at the Reformation, and for many years it was in my own care. I suspect that I handled it more often than Becket did. I used to show it to classes of students sometimes, and remarkably often one would furtively reach out a finger to touch the edge of a page, evidence that a sense of momentary encounter with Thomas Becket still carries a secret thrill. On the manuscript's flyleaf at the front it has the medieval title using almost exactly the same words as in the fourteenth-century Canterbury catalogue, including the fact that it had formerly been owned by Saint Thomas (his name now erased). These medieval titles written in Canterbury books and their parallels in the inventories will have a particular importance later in this story.

A substantial part of the list of Becket's books in the medieval library comprises glossed books of the Bible. There are at least twenty-two such volumes recorded, from a single glossed Genesis right through to a glossed Apocalypse at the end of the New Testament. Glossed books were a recent twelfth-century phenomenon, which were promoted from the schools of Paris under and following the mastership of Peter Lombard (d. 1160), teacher of Herbert of Bosham. They were a new type of manuscript that brought together short extracts from the works of earlier commentators on the Bible and arranged them accessibly on either side of a central column of biblical text, so that a reader could quickly

become expert in scriptural interpretation without the necessity of reading ancient homilies and commentaries from end to end. It was doubtless Herbert who encouraged Thomas Becket in the acquisition of such convenient texts, and this is the earliest more-or-less comprehensive set recorded. At least three of Becket's volumes survive, one in the Bodleian Library in Oxford, a gift in 1616 from the sons of a prebendary of Canterbury, and two more, by a route now familiar, in Trinity College, Cambridge. They are all mighty and noble manuscripts, including respectively the glossed texts of the Pentateuch (Genesis to Deuteronomy), the twelve Minor Prophets, and the four Gospels. The manuscripts are spectacular, exceptionally large and glittering with gold. They have sparkling illuminated initials crawling restlessly with writhing dragons and little yellow-white lions clambering through the foliage. One initial includes a vignette of an archbishop, surely Becket himself, richly robed and raising a gloved hand in blessing against a burnished gold background (Plate 5). In these glossed books we are confronting the famously extravagant taste of Thomas Becket, which both shocked and awed his contemporaries. He was probably encouraged by Herbert of Bosham, himself a notoriously flashy dresser whose own manuscripts were richly illuminated. Becket's glossed books are no modest Cistercian productions from Pontigny or intellectual rarities recommended by quiet John of Salisbury. However, consider the nature

of the texts. Glossed books were fashionable, certainly, but they were also convenient manuals for instant erudition. Becket's library had almost none of the old traditional texts of leisurely monasticism and cloister reading, such as Augustine, Jerome or Bede. Instead, the list records the latest manuscripts of summaries, glosses, florilegia (including one with usefully prepared quotations from Saint Gregory), new encyclopaedias (such as Peter Lombard's *Sentences* for theology) and guides to learning in a hurry. He had the *De officiis* of Isidore of Seville, an elementary dictionary for the use of the clergy. These are books for consultation and providing quick answers. Perhaps here, almost for the first time, we are seeing the intellectual vulnerability of Thomas Becket reflected in his library hastily assembled for him in France. The chancellor-turned-archbishop was not even a priest at the moment of his appointment. He needed theology and learning with urgency, and the books expose his insecurity.

Finally, before we leave the medieval booklist, there are a few volumes which might have been student textbooks left over from long ago. We all have some, remnants of youth which we are reluctant to discard. A Psalter with the gloss of Anselm of Laon (d. 1117) was out of date by the 1160s, superseded by the greater version by Peter Lombard (which Becket had too), but it might have been known to him in the schools of the late 1130s, perhaps indicating an early interest in the

Psalms. There is a rather good little clutch of law books, mostly of Roman law, which could have been acquired during his legal studies in Auxerre and Bologna in the time of Archbishop Theobald. None survives, and so we cannot guess their date. They remind us that Becket, although ill-prepared for deep theological controversy, was not uneducated.

John of Salisbury and Herbert of Bosham would not have regarded Becket's books as relics, any more than the monks of Canterbury did. John owned a miracle-working vial of Becket's blood, which he had apparently scooped up at the time of the murder (he was there), and Becket's little pocket knife, which maybe qualified as a relic because it had been worn on the body and was therefore part of Becket's clothing. Herbert of Bosham missed the martyrdom, to his lasting regret. He was afterwards scornful of those who venerated the new saint's body while ignoring Herbert himself, a 'living relic' of Saint Thomas. At best, however, books were only 'secondary' relics in the Middle Ages. This was not unique to Becket's library. There are books which had belonged to other saints, or were thought to have done so, which were nevertheless kept in medieval libraries with routine manuscripts, including volumes once owned by Saint Augustine of Canterbury, Bede, Saint Dunstan, and Saint Anselm. There are two famous exceptions. One is the so-called 'Saint Cuthbert Gospel', discovered in the coffin of Saint Cuthbert

when it was opened in Durham in 1104. When a monk impiously fingered it in Durham Cathedral in the early twelfth century, his leg supernaturally swelled up. Here is the important point. The miracle was not caused by the manuscript: the monk stole a loose thread from the silk strap of the book's carrying case. In other words, this was part of what was worn on the saint's body and so it was a primary and therefore miracle-working relic. The second exception is the Ragyndrudis Codex in the cathedral treasury of Fulda in Germany. (Its strange name is that of its scribe.) It traditionally and credibly belonged to the Anglo-Saxon missionary Saint Boniface, who was martyred by the Frisians in 754. An early account of the saint's death describes how he tried to protect himself from his assassin's swords by raising the manuscript over his head, and the original binding and upper edges of many pages of the Ragyndrudis Codex are indeed gashed with these horrific cuts, which was why it was preserved. The book became a relic through its part in its owner's martyrdom.

While medieval pilgrims were mobbing the shrine of Thomas Becket in the cathedral in their tens of thousands, hoping for a dab of miraculous water which after several centuries of dilution and sale by the monks had no conceivable contact with the blood of the saint, the archbishop's books, which he had actually commissioned and read and touched, were neglected on the open shelves in the slype off the cloister. Even before

the end of the Middle Ages, many had been lost or discarded. Two of Becket's textbooks of civil law were sent up to Canterbury College in Oxford, as duplicates for the daily use of students, and were never seen again. This was not ignorance: the monks knew they had been Becket's, but they did not care. His copy of Aulus Gellius, by then missing leaves, was apparently in Padua in the fifteenth century, where its defects were made up by the Italian humanist Pietro da Montagnana (d. 1478). It may have been taken there by someone such as the amateur scholar John Tiptoft, earl of Worcester (beheaded in 1470), who had close connections with both the library at Canterbury and the university in Padua. It is now in Paris. Becket's copy of Cassiodorus belonged to the Bristol antiquary William Worcestre (d. c. 1482, no relation), well before the Reformation, and it found its way to Magdalen College in Oxford with other manuscripts from Worcestre's library. There is modern circumstantial evidence that the spectacularly illustrated 'Eadwine' or 'Canterbury' Psalter, now in Cambridge, may well have been commissioned by Becket. If it was, the monks of Canterbury were utterly indifferent to the fact. It was only a book.

On the other hand, they carefully preserved and exhibited two mitres which had belonged to Becket (the gold one in which he was first buried and the white one he actually used), his embroidered gloves, his hair shirt, his bedclothes and bed hangings, his belt, his monastic

cowl, his flail made of thongs, his chasuble, his sandals, and even his raincoat (if I correctly interpret '*capa pluviali*' in the cathedral inventory). All these were destroyed at the Reformation, but there are still a number of surviving liturgical garments elsewhere, venerated because they were said to have been worn by Becket. These include vestments exhibited among the relics of the cathedral of Sens in France, where Becket had moved after leaving Pontigny; a linen shirt in the cathedral in Arras, with stains said to be blood; a chasuble owned by the Jesuits of Courtrai; another vast embroidered chasuble of oriental textile preserved by the cathedral of Fermo in Italy and displayed in the Museo Diocesano there; and a tunicle kept in a seventeenth-century glass reliquary in the Vatican.

Some years ago, I invited the biblical historian Eyal Poleg to lunch at Corpus Christi College in Cambridge, and conversationally over coffee afterwards I outlined something along the lines of what I have just said, which is that it has always seemed to me curious that, unlike clothes, saints' books in medieval England were not regarded as relics. Dr Poleg said that he knew of a medieval reference to what had clearly once been an exception. He tapped at his laptop, and he brought up an entry datable to 1321 from the Sacrist's Roll of Canterbury Cathedral, describing a precious but never-traced manuscript among the treasures in the cathedral.

It was probably used in the liturgy around the shrine of Thomas Becket in Canterbury, as he explained. (The sacrist was the official in charge of relics.) The description begins, in Latin, '*Item, Textus cum psalterio Sancti Thome, argento deaurato coopertus gemmis ornatus . . .*', 'Item, a binding with the Psalter of Saint Thomas, bound in silver-gilt decorated with jewels . . .' (Plate 7), and I had one of those sudden heart-stopping shivers of recognition that make our lives as historians worthwhile, for I remembered seeing those words before. They occur almost exactly transcribed into a late tenth- or early eleventh-century Psalter in the Parker Library, a few hundred yards from where we were then sitting in the college's Old Combination Room. We abandoned our coffee and rushed across the courtyard to the library, and I brought out MS 411 from the vault (Plate 6). We sat in the reading-room looking at it together, trembling with excitement.

The manuscript is well-known. It is one of the notable Anglo-Saxon books that were brought to Corpus Christi College in the bequest of Matthew Parker, archbishop of Canterbury 1559–75. In a lower margin at the very end of the text is a sixteenth-century Latin note, probably from Parker's lifetime. It says, in translation, 'This Psalter, in boards of silver-gilt and decorated with jewels, was once that of "N" archbishop of Canterbury [and] eventually came into the hand of Thomas Becket, late archbishop of Canterbury, as is recorded in the old

inscription' (Plate 8). This claim has always been dismissed as a piece of credulous antiquarian fantasy, including in the recent catalogue of illuminated manuscripts in Cambridge colleges (2013), stating it to be 'almost certainly a complete fiction'. In fact, Becket was so out of fashion in Elizabethan England that it would have been an unromantic and unlikely fiction to have invented at that time.

First of all, note that reference to 'the old inscription'. No such inscription survives. It was the custom at Canterbury, as we have seen, to repeat the wording of the inventory at the top of a manuscript's first page or on a front flyleaf, as in the *Polycraticus* and others. The original leaf before folio 1 is now missing. The book's binding is eighteenth century (July 1750, in fact, as the College archives show), and dusty stains suggest that the volume remained without covers for a long time. If the end leaf at the front with the 'old inscription' had by then come loose, it is very likely that its information would have been saved for Parker on to another page.

The passage of such a book from Canterbury Cathedral at the Reformation to Matthew Parker is extremely simple and logical. Parker (1504–75) was one of that early generation of sixteenth-century English antiquaries alarmed that the wanton spoliation of the former monasteries was destroying the unique written records of our national history. He was particularly concerned with saving manuscripts from before the Norman

Conquest of 1066, because it was felt that the Anglo-Saxon Church then still had a distinct national identity not yet corrupted by the later tentacles of papism from mainland Europe. Anything older than the Conquest was regarded as uniquely English and independent. On becoming archbishop in 1559, Parker was tasked by the young Queen Elizabeth with making the Reformation in England absolute and irrevocable. The resulting Elizabethan Settlement, as it is called, was buttressed by Parker with the tangible precedent of history. It was an important tenet of the newly restored English Church that it preserved the old Anglo-Saxon administrative structure of cathedrals with bishops and archbishops. Their line of accountability, however, led to the king or queen of England, as it had apparently been in practice before the Conquest, and not to the pope. 'The Bishop of Rome hath no jurisdiction in this Realm of England,' stated the new *Thirty-Nine Articles*, the manifesto of the reformed Church as promulgated by Archbishop Parker in 1571 and still part of the legal definition of the established national Church.

As regards Thomas Becket, Matthew Parker had an ambiguous position. He was obliged to support the suppression of the cult of Becket, as commanded by Henry VIII, father of Queen Elizabeth. Parker's injunctions for Canterbury Cathedral in 1560 included orders for the defacement and destruction of pictures and painted verses about Becket, 'sometime Archbishop

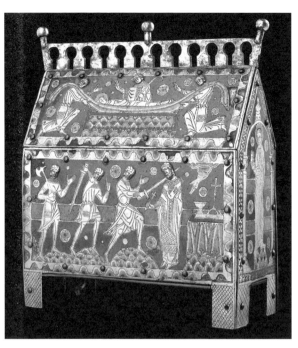

1. A late twelfth-century Limoges enamel casket made for relics of Becket, with pictures of his martyrdom and burial.

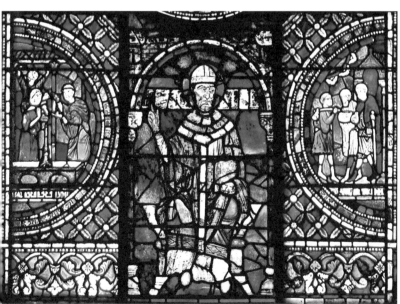

2. Stained glass window in Canterbury Cathedral, showing Becket holding a book.

Incipit p̄ demō̄stracō̄ cū ordinis.
Distinctio p̄ma.
Liber de olomie.
Genesis glō.
Pentateucus glō.
Biblia.
Iosue glō.
Inbuolūie ornement.
Liber iudicū. lib. Ruth.
Regū glo. & paralipomenō.
Psalteriū secūdū anselmū.
Psalteriū secūdū Longobard.
Parabole salomōis glō.
Ecclastes glō.
Lib. sapientie. glō.
Psalmus glō.
Ieremias. glō.
Epistola ieremie glō.
Lamentaciones ieremie glō.
Ezechiel glō.
Duodeci pphete glō.
Daniel cū lōni.
Quatuor euū̄gelia glō.
Marcus glō.
Iohēs glō.
Epistole canonice glō.
Epistole pauli secūdū longobardū.
Epistole pauli secūdū anselmū.
Apocalipsis glō.
Hernie longobardi.
hugo sup ecclastē.
Item hugo sup cātica.
In buolūie ornement.
hugo de distinctiā diuine theo
logie & mixture.
hugo de archa noe.
Raban sup cātica.
In buolūie ornement.
Cronica de vii. etatib seculi.
Etate qui de omie capō langd.
Omelie Greg.
Marnerii gregorian.
Isidorus de genie offior.
In buolūie ornement.
Tullius tusculanarū.
Ambrosius de officiis.
In buolūie ornement.

Ambrosius de sacrament.
Item ambrosius de paradiso.
Ambrosius de patriarchis.
Ambrosius de scō ioseph.
Ambrosius de bñdictōib patriarch.
Ambrosius de apologia dauid.
Ambrosius de vinea naboth terra
dare.
Ambrosius de ieiunio.
Ambrosius de pastoribz.
Ambr de pēnitencia.
Prima ps tici lini.
Beda ps tici lini.
Agellius Noctiū atticar.
Distinctio secūda.
Prisciani cursus.
In buolūie ornement.
Vegetius de re militari.
Solinus.
In buolūie ornement.
Valerii maximi de dictis & factis me
morabilibz.
Historia troianor.
Seruius sup Kauennatis.
S. Guerric albis.
S. Ectora foxreg.
S. b̄z quidā erunt Diues.
S. Gubinatoz pruder.
S. Lodie dilectissimi.
S. Afcendr deus.
S. Longe afpicieba.
Item S. Afpiciebam.
Carriole.
Lib exortacionū bi Bñardi. ad
eugeniū pp̄m.
In buolūie ornement.
Bñard de amore dei.
Abzauiacō breuis vitae.
Lib odonis pioris de moribz eccl.
Epistole cipriani.
In buolūie ornement.
Apologetic gregor nazanzeni.
Epistole Reg arlumensiū.
Valerius. Codex.
Inforciatū.
Digestū vetus.
Digestū nouū.

Instituta.
Item instituta.
Lib de sparagōne tituloz.
Item lib de pace tituloz.
In buolūie ornement.
Queda cōpilacō legū.
Item exactis.
Presciamus magn.
Presciani ostructions.
In buolūie ornement.
Athuelsim psalmū.
Psalmū de arreneib.
Psalmū de vsibz vigilii.
Psalmū de nocte pñote & vlto ad
instructionē pueror.
Beda de arte metrica.
Donate de barbarismo.
Beda de scematib.
Donate de arte metri.
Etne de iii. alphabetis. i la
meracoib ieremie.
Marcian capella. l. ix.
Lib guillam l. v.
In buolūie ornement.
Dii legum.
Lib senece de damacoib.
Marciani cocis.
In buolūie ornement.
Item auarinu.
Item apopleria maraini.
Vegeti de re militari.
In buolūie ornement.
Libell de situ urbin & loca stię.
Policratie iohis l. viii.
In buolūie ornement.
Metbalogicon eiusd. l. iii.
Lib an bechera de Bolebm.
Prima ps psalterii secūdū longo
bardum.
S. ps psterii sm longobard.
Prima ps eplar pauli secūdū
longobardi.
S. ps eplar pauli sm longob.
Thomus.
Distinctio tercia.
Lib Radii remensis.
Genesis glosata.

3. Becket's books listed in the early fourteenth-century library catalogue of Canterbury Cathedral Priory.

4. Becket's Odo of Morimond, executed in Cistercian style.

5. Becket's glossed Gospels: the lower figure is a probable portrait of Becket himself.

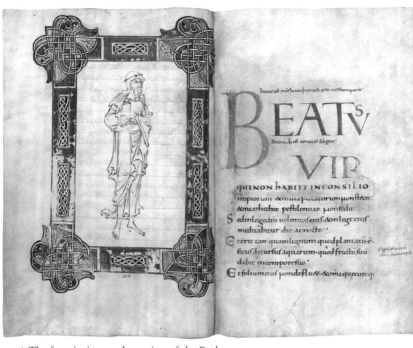

6. The frontispiece and opening of the Psalter.

7. The entry in the sacrist's inventory listing the Psalter in the early fourteenth century.

8. The sixteenth-century inscription in Becket's Psalter, attesting to his ownership.

·LI·

Q
VID
GLORIARIS

9. The opening of Psalm 51 in the Psalter (in the medieval numbering), in Franco-Saxon style.

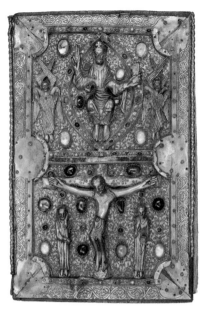

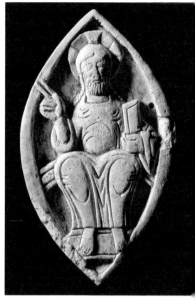

10. The eleventh-century jewelled binding on the Gospels of Judith of Flanders.

11. An eleventh-century ivory of Christ in Majesty from a book cover, found in Kent.

S cē laurentı
S cē uincenii .11 .
S cē apollonarıſ
S cē geruaſı
S cē protaſı
S cē xpophorē
S cē georgıı
S cē dıonıſıı cum ſocıiſ
S cē euſtachıı cū ſocııs
S cē berafine
S cē oſuuolde
O mſſcī martyreſ orate
S cē benedicte .11 .

S cē columbane
S cē antonı
S cē arſenı
S cē machari
S cē caurentine
O mſſcī confeſſoreſ
O mſſcī monachı & herem
S cā felıcıtaſ
S cā perpetua
S cā marıa magdalene
S cā ſcolaſtıca
S cā agatha
S cā agneſ

12. The litany of the Psalter, according special attention to Saints Vincent, Eustace and Benedict.

quę ñ auferetꝰ ab ea. IN PASSIONE SCI
ALFEGI ARCHIEPI. Scdm Iohanñe.
In ill'. Dixit ihc discipulis suis. Ego sū pa
stor boñ. Boñ pastor: animā suam dat p
ouib; suis. Mercennari & q ñ est pastor cui
ñ st oues ꝓprie: uidet lupū uenientē & di
mittit oues & fugit. Et lupꝰ rapit: & disp
git oues. Mercennariꝰ autē fugit qa mer
cennariꝰ est: & ñ ptinet ad eum de ouib;.
Ego sū pastor boñ. Et cognosco meas: & co

13. Readings added in the Psalter in the twelfth century for the Passion of Saint Alphege.

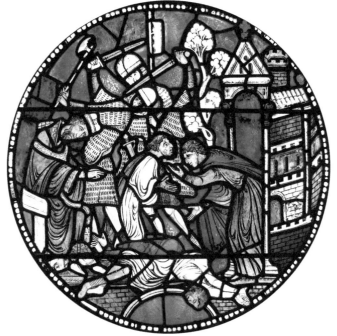

14. Stained-glass window in Canterbury Cathedral, showing the martyrdom of Saint Alphege.

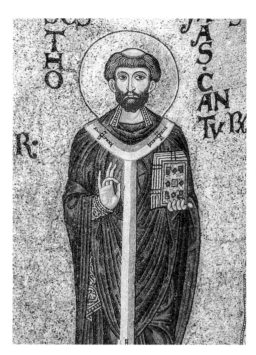

15. Twelfth-century mosaic in Monreale, Sicily, showing Becket with a book in a jewelled binding.

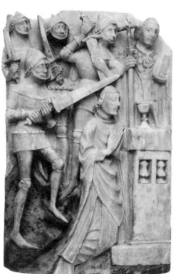

16. A fifteenth-century alabaster of Becket's martyrdom, with a chaplain holding a book.

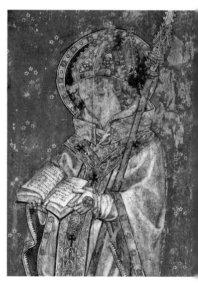

17. Detail from the fifteenth-century rood screen of Ranworth Church, Norfolk, showing Becket with a book.

of Canterbury', a phrase like that used in the Psalter. On the other hand, Parker's authority depended on an unbroken line of archbishops of Canterbury back to Saint Augustine in 597 and earlier, through Augustine's appointment by Gregory the Great, implicitly through apostolic succession back to Saint Peter and the foundation of Christendom. In Parker's numbering, Becket was the thirty-eighth archbishop as he himself was the seventieth. He wrote a history of the lineage of the English Church (1572) with lives of all the archbishops, reprinted in English in 1574. He owned an impressive number of medieval biographies of Becket, including three of the five known manuscripts of the life of Becket by John Grandison (the only three in England), and the unique copy of a Middle English verse text based on Herbert of Bosham's biography, which has the touching association that the manuscript was owned before Parker by Thomas Cranmer, himself archbishop of Canterbury and later martyr. Parker's life of Becket in his history of the Church interpreted his quarrel with the king as interference by the pope and his canonization as papal.

In 1568 Parker obtained licence from the Privy Council to take into his own custody any manuscripts in England that would justify his own interpretation of history. Many came from medieval libraries of the old cathedrals, such as Worcester, Ely and Exeter. By far his largest single source was Canterbury. As archbishop,

he had easy access to the shelves. At least thirty of his acquisitions came from St Augustine's Abbey in Canterbury and more than thirty-five from the cathedral, including in both instances their oldest manuscripts. Parker was not the slightest bit interested in Psalters or liturgical books in general. He was offered the eighth-century Vespasian Psalter from Canterbury and returned it as irrelevant. He was, however, very interested in archbishops. The reason he wanted the Psalter now designated MS 411 was doubtless because of that old inscription indicating that it had belonged to one archbishop of Canterbury and had come into the hands of another. He probably recognized it as pre-Conquest, and he would therefore consider it noteworthy that it was used by Archbishop Becket during the then corrupted time of the Normans. The year before his death, Parker entrusted his collection to his old college in Cambridge, where he had previously been a student and then master.

The manuscript is not especially large or thick, about 8¼ by 6 inches, with 146 parchment leaves. The text comprises the 150 psalms from the Old Testament, attributed by tradition to King David, in the late fourth-century Latin translation of Saint Jerome known as the Gallican text, taken from the Greek. This was the standard version of the psalms throughout the European Middle Ages and was used (and is often still used) in monasteries during the daily liturgy. The manuscript

has no calendar, as a later medieval Psalter would. The text is followed by the apocryphal psalm *Pusillus eram* and other standard biblical canticles, both Jewish and Christian, such as the Song of Isaiah (Isaiah 12:1–6), the *Benedicite* (Daniel 3:57–88), the *Magnificat* (Luke 1:46–55) and the *Nunc dimittis* (Luke 2:29–32). There are also basic Christian texts such as the Lord's Prayer, the *Te deum*, the Apostles' Creed and the Athanasian Creed, which opens '*Quicumque vult . . .*' At the very end are litanies and short prayers. All this is conventional and unexceptional. It is in Latin throughout, the language of medieval literacy but also regarded as one of the three sacred tongues, because it had been used above the Cross at the Crucifixion. It is clearly a book for personal use, a practice becoming increasingly common for wealthy individuals from the ninth century onwards. It would not be used in the liturgy but contained all that was essential for private devotion.

It is a tactile and graceful book, quite light in weight and easy to hold. It is written in the neat round script known as Caroline minuscule, as uniform and legible as the work of a typewriter. The manuscript has decorative borders and several large interlaced initials in black and red ink, mostly filled with light-coloured washes in what is called the Franco-Saxon style (Plate 9), still current in parts of France in the Carolingian period and ultimately deriving from the ornament of even earlier Irish or insular manuscripts such as the Book of

Kells and the Lindisfarne Gospels. The opening border includes the heads of creatures that look like ducks, although they might be dragons or other monsters. These are all characteristic of Franco-Saxon decoration. It was once thought that the Psalter was actually French, but it was noticed in the 1950s that the same scribe copied a Boethius with Old English glosses, also attributed to Canterbury and now too in the Parker Library. A prayer towards the end of the Psalter addressed to all confessors begins by invoking Saint Gregory and his sending of Saint Augustine of Canterbury to preach to the English nation, and it is overwhelmingly probable that the manuscript was made in Canterbury, where Augustine preached and was first archbishop. This was one of the few centres of book production still active in England in the decades on either side of the year 1000, during a time of renewed incursions by the Vikings.

The manuscript opens with a frontispiece of a standing figure drawn in ink in the vibrant and sketchy Anglo-Saxon style of the mid eleventh century, floating within the rather earlier Franco-Saxon border (Plate 6). The assumption is that the space was originally left blank when the manuscript was finished and that the figure was inserted a generation later. It is something of a puzzle, for it has none of the obvious attributes of King David, author of the Psalms, such as his usual crown and harp. The colours in the border include yellow, coppery green (which has a tendency to flake),

orange-red and an intense deep blue. Recent analysis of the manuscript by Raman spectroscopy has revealed that this last pigment is Egyptian blue, that bright turquoise colour made uniquely in ancient Egypt by fusing sand with calcium and copper compounds at extremely high temperature and used for the famous blue glaze on figurines and ushabtis. It has been identified in about half a dozen Anglo-Saxon manuscripts, almost all from Canterbury. Somehow the monks there had access to an original Egyptian antiquity, from which they must have scraped the glaze and then ground it up for re-use as pigment. The Mediterranean trade routes still have mysteries that are not yet understood. One may think of Egyptian antiquities as arriving in England only with the Rosetta Stone; they were in Canterbury over a thousand years ago. Some ancient artefact might even have been brought as a supposed relic of the sojourn of the Holy Family in Egypt during the persecution of Herod.

Let us look at the entry for the Psalter in the sacrist's inventory, for this too indicates with great probability that Becket's book was already of some age even in his time. The description which Eyal Poleg told me about occurs in the earlier part of the same manuscript, now in the British Library, that includes the medieval library catalogue of Canterbury, cited earlier. The volume comprises many inventories and documents of different kinds assembled in the time of the great recorder, Henry of Eastry (d. 1331), prior for forty-six years from

1285. This section begins with a heading introducing it as a list of the *textus* (we will come to this word in a moment) and the relics of the cathedral, catalogued on the feast of the Purification 1315 (Candlemas, 2 February, which probably means what we call 1316 since the year ended on 24 March), recorded by the sacrist Richard of Sharstede (d. 1316) and by the sub-sacrist John le Spycer (d. 1336), and then confirmed by an indenture by John le Spycer again with Robert of Dover, by then sacrist, and William of London (d. 1333), sub-sacrist, all witnessed by Henry of Eastry himself and his chaplain Denis, on the day after All Souls, 3 November, 1321.

The list comprises items that were used in the liturgy and kept in the church near the altars or shrines where they were required. The word *textus* is a common term in the Middle Ages for a Gospel Book, a holy text with the status of a relic, and its use here in the sacrist's inventory does imply some sacred function. However, it literally means a cover, from the Latin verb *tego – texi – tectum*, and it came to be the word for a jewelled or treasure binding for any hallowed book. It is one of a group of twenty-two such items listed, most of which were doubtless Gospel Books, including one with the interesting name *Domus Dei*, the House of God. One *textus* was explicitly a Psalter (this one), and three were described as being '*sine libro*', empty treasure bindings without books at all. A parallel use of the word *textus* for a sacred manuscript which was not a Gospel Book is

in the inventory of Rochester Cathedral nearby, which listed a *textus* containing the life of Saint Andrew, that cathedral's patron saint, for use in the liturgy.

The sacrist's entries are almost entirely concerned with the ornament. That for the Psalter says in full: 'Item, a *Textus* with the Psalter of Saint Thomas, bound in silver-gilt decorated with jewels around the edges with an ivory Majesty holding a book in the centre and four sculpted evangelists.' A 'Majesty' means a figure of Christ enthroned in glory. Ivory at this time usually meant tusk of walrus rather than elephant. The 'sculpted evangelists' may have been metalwork. The custom of decorating the covers of sacred books with gemstones and ivories goes back to late Antiquity. Most surviving examples of treasure bindings are Carolingian or Ottonian. They are extraordinary artifices but to modern eyes resemble glitzy fairground bling, and the gems are often of poor quality. They can perhaps be truly appreciated only in the pre-dawn setting of liturgical processions by candlelight. They always risked theft or demolition when jewels and money were in short supply. There are treasure bindings of the eleventh century in the Morgan Library and Museum in New York, covering the two Gospel Books of Judith of Flanders, countess of Northumbria (d. *c.* 1094–5), both with figures of Christ in Majesty (in metal). They are possibly but not certainly English (Plate 10). Another once covered the early eleventh-century Gospel Book

of Countess Godgifu (d. *c.* 1049), sister of Edward the Confessor, now in the British Library. It was given by her to Rochester Cathedral, and the binding was listed as being 'ornamented with silver and precious stones'. It was written in Canterbury and is likely to have been bound there.

By the time of Becket, jewelled bindings with ivories were already out of date. The fashion by then was for the ornamentation of sacred texts with Limoges enamels, dramatic panels of pictures formed of puddles of brilliant liquid colour in frames of gilded copper. As it happens, the earliest written reference to Limoges book covers occurs in a letter from the Becket correspondence. One John, a cleric or monk from the church of Saint-Satyre, was part of Becket's household in exile in France in the late 1160s when he wrote to Richard of St-Victor (d. 1173) in Paris about two Limoges book covers he wanted to send to the abbey of Wingham in Kent. He calls them '*tabulas texti*' – that word again – '*de opere Lemovicino*', '*textus* panels of Limoges work'. There are two examples of *textus* listed in the sacrist's inventory of 1321 which are demonstrably later than Becket. One had belonged to Edmund earl of Cornwall (1249–1300) and showed the Crucifixion. Another, an empty *textus* without a book, showed the martyrdom of Thomas Becket himself. Both were very probably Limoges plaques. If the binding of Becket's own Psalter still had gemstones and an ivory carving it

was almost certainly made before his lifetime, and it was most probably pre-Conquest. As much as anything, this makes the identification of MS 411 in the Parker Library as the Psalter recorded in the relic list more-or-less absolute.

The ornament of a medieval jewelled binding might sometimes be on both covers, or on one only. The inventory entry describes only one side. This would usually be the back cover, for a manuscript was customarily displayed on an altar or held in the left hand with its front downwards and would be opened with the right hand from the back. The precious stones and the ivory would be held in place by metal pins nailed through the binding's wooden boards, and the tips of these pins would be hammered flat on the inner side of the board. This can be seen on the Gospel Books of Judith of Flanders in New York. The nails might often leave marks on any page once pressed up against them. The medieval flyleaf at the very end of MS 411 shows such traces quite clearly. There are rusty indentations around the edges and in a vertical line towards the spine. The centre is free of marks, where the ivory plaque would have been attached. When Becket's shrine was destroyed in 1539 and all gold and silver was forfeit to the Crown, the cover would have been torn off the Psalter, which would be why it was unbound in Parker's time. An ivory had no treasure value and would probably have been thrown away. In 1991 the British Museum acquired an eleventh-century Anglo-Saxon ivory of Christ in Majesty (Plate 11). It is reported as

having been found in east Kent (near Canterbury there-
fore) and is assumed to be from a book cover. It is just
over three inches high in the almond shape of a man-
dorla, precisely the right size. It shows a seated figure of
Christ holding a book, as described in the inventory, rais-
ing his right hand in blessing. Especially when writing
about relics, I must not make the mistake of credulous
identification based on wishful thinking, but it is at very
least an example of the kind of ivory that must once have
been attached to the manuscript.

The inscription in the Psalter asserts that it had once
belonged to 'N' the archbishop. The only Canterbury
candidate with that initial had been Nothelm, arch-
bishop for four years in 735–9, clearly inconceivable,
even to the writer of the note. It has been suggested
rather implausibly in this context that it may mean
Nomen, a medieval formula for an unspecific person.
The Psalter was certainly for personal use, not for
the public liturgy. Unaware of the Becket association,
Mildred Budny's catalogue of the Anglo-Saxon manu-
scripts in the Parker Library (1997) describes it as 'a
book fit for an archbishop', judging mainly from its pri-
vate status and superior quality. The primate at the time
of the likely dating of the manuscript was Ælfric, arch-
bishop from 995 to 1005. The Psalter has the unusual
feature of a second litany added by a different but con-
temporaneous scribe at the end of the volume, calling
upon the names of saints to pray for its user. Among the

standard saints listed are four names written in capitals with double invocations. They are Saint Peter and Saint Benedict, the founders of episcopacy and of the Benedictine Order, and, unexpectedly here, Saints Eustace and Vincent (Plate 12). Major relics of both these two saints were owned in Anglo-Saxon England by Abingdon Abbey, and it has been speculated that the manuscript might have been intended for Abingdon. This is not necessary, however, if the owner was Archbishop Ælfric, for he had himself professed as a monk of Abingdon and had probably been abbot there before his appointment to Canterbury. The sacrist's list of 1321 includes two small relics from each of them, possibly brought by Ælfric on his arrival from Abingdon in 995. Ælfric is credited with introducing monasticism to the cathedral on the orders of the pope, which may further explain the litany's emphasis on Saints Benedict and Peter. Ælfric died soon after the stylistic date of the manuscript, which may be why some initials appear unfinished and the frontispiece portrait was not yet added.

If this was an archbishop's book, it would have passed to his successor. This was Ælfheah, or Alphege, who held office 1006–12. Alphege was undoubtedly a saintly man and a former anchorite in the West Country. He had reluctantly allowed himself to become abbot of Bath and bishop of Winchester. He was archbishop during the siege of Canterbury by the Danes in September 1011. Alphege himself was kidnapped and the

cathedral was burned, with the loss of very many of its books. The Psalter may have survived by remaining with the archbishop during his imprisonment. The early life of Alphege by Osbern (d. *c.* 1094), precentor of the cathedral priory, describes him as joyfully reciting the psalms in captivity. On 19 April 1012, Alphege was beaten to death by the Danes at Greenwich, near London. He was the first, and until Becket the only, archbishop of Canterbury to suffer martyrdom (Plate 14).

Let us suppose for a moment that this was Alphege's Psalter. In 1023 his possessions and relics were sent back from London into the custody of the monks of Canterbury. In 1078 he was canonized as Saint Alphege. Now reconsider the inscription attributing possession to an improbable 'N' the archbishop. The name of Alphege in Anglo-Saxon began 'Æ', a letter not known in Elizabethan England, when a copyist transcribing an old title, necessarily obscure if it had to be re-copied at all, could easily have misread a faded and obsolete 'Æ' for 'N'. That strange added eleventh-century frontispiece, not obviously David, might possibly be a drawing of Alphege himself holding his Psalter. Osbern's life graphically characterizes Alphege with bare feet and simple clothes standing in prayer. The tall bare-footed figure here wears a plain diadem of a martyr, but no halo, consistent with a date between 1023 and 1078. It gets better. On the flyleaves at the end of the Psalter are liturgical readings added in the prickly Norman script

typical of the cathedral priory in the early to middle twelfth century, '*In passione sancti Ælfegi archiepiscopi*', 'On the passion [or death] of Saint Alphege' (Plate 13), using an initial for his name which looks very like an 'N'. Medieval owners of manuscripts often did strange things, but the simplest explanation of an office for the death of Saint Alphege in a text as unceremonial as a private Psalter is that it was in some way associated with his cult. If Alphege was thought to have had the manuscript with him at the time of his murder, it would, like the Ragyndrudis Codex of Saint Boniface, have become a relic.

Finally, we come back to Thomas Becket. He was consecrated archbishop in 1162. The chancellor of famously extravagant taste could not have failed to notice the jewelled binding of the Psalter in the cathedral. Later events seem to suggest that Becket in some way adopted Alphege as a patron saint, the archiepiscopal outsider encircled by his enemies and eventually martyred, and it is entirely plausible that he took the hallowed Psalter of previous archbishops into his possession. This again is consistent with the wording of inscription, that the Psalter of 'Æ' came into the hands of Thomas Becket, also archbishop.

There is evidence that there was indeed one precious book in Canterbury from which Becket never wished to be parted. It has never been identified. After the disastrous confrontation with Henry II at Northampton in

October 1164, when Becket was charged with treason, he escaped through a rainswept night across the fens of Lincolnshire, disguised as a Gilbertine lay brother, and eventually found a boat on the evening of 2 November to take him across to Flanders and into exile, carrying nothing but what he had with him. However, he had sent Herbert of Bosham secretly to Canterbury, having arranged to meet him at the abbey of St-Bertin, not far from Calais. Herbert describes the mission in his biography of the saint. He says that Becket tasked him 'to take care of a particular book of his, lest when his flight was known to other people, it might be destroyed in the plundering. In which' – Herbert continues piously – 'it may be seen how, although he was rightly indifferent to possessions, of which he left behind such quantity and of such richness, there was at least one little book which he cared about.'

The Old Testament psalms are among the oldest and most powerful spiritual texts in any language, and we cannot guess Thomas Becket's response to reading them. If the book was as precious to him as Herbert of Bosham suggests, he doubtless did read them. It may have been his most intimate possession; he probably took it to bed. John of Salisbury's advice to Becket at Pontigny was that he should 'ponder the psalms and turn over the moral writings of Saint Gregory'. For the latter, he duly acquired the latest one-volume summary of Gregory, the *Gregorianus* of Garnier of St-Victor

(d. 1170), recorded on his booklist. For the former, he must have had a Psalter. Herbert of Bosham recounts how Becket at Pontigny was constantly meditating on two books, the Psalter and the Epistles of Saint Paul. One of the very few letters written by Thomas Becket himself opens with the words '*Expectans expectavi*', quoting from the beginning of Psalm 39. Herbert of Bosham (twice) describes Becket using devotions and psalms in private with the humility and simplicity of their author, King David. It is an apt model, if Becket was aware of it himself, for the biblical psalmist too had been plucked from a relatively humble background into the household and intimate friendship of a volatile king (Saul), who then turned against him in jealousy and anger and tried to have him killed.

Becket would have read Psalm 145:3, 'Put not your trust in princes, in the children of men, in whom there is no salvation.' This is on folio 121r here. He surely read Psalm 109:5, 'The Lord at thy right hand hath broken kings in the day of his wrath.' Above all, he must have read Psalm 51, 'Why dost thou glory in mischief, thou that art mighty in iniquity?', which in this manuscript (and others) has a note explaining that this psalm refers to the controversy between King Saul and Doeg the High Priest, as a result of which the king ordered the High Priest's death. This is some-times actually shown in manuscripts as a mirror image of the murder of Becket, as in the Winchester Bible, in

which Psalm 51 is illustrated by a cleric being struck down by three knights. That initial was probably illuminated shortly after Becket's death for Henry of Blois, the senior bishop who had consecrated Becket himself. If we are ever to approach the mind of Thomas Becket in private, it will be through knowledge of his reading of the psalms.

If this was also the Psalter of Saint Alphege, the manuscript would have had increasing application to the archbishop returning to England to face probable death. His sense of martyrdom and its significance to Canterbury may have been heightened or focused by use of this particular manuscript. He must often have read the designated readings for the passion of Saint Alphege. The first is from John 10:11–16, beginning, 'I am the good shepherd. The good shepherd giveth his life for his sheep.' His sermon in Canterbury Cathedral on Christmas Day 1170, three days before his death, was on the subject of the death of Saint Alphege, in which the archbishop foretold that there might soon be a new martyr.

Several of the earliest pictures of Thomas Becket show him carrying a book. If Herbert of Bosham was right that there was one little book which was precious to him, this might be it. The oldest image of Becket as a saint is a mosaic in Monreale in Sicily, perhaps based on information from people who knew him personally, including Joan of Sicily, daughter of Henry II,

and Becket's own nephew, who both lived there. He is shown holding a book of the right size for a Psalter, and it is indeed profusely jewelled on its back cover (Plate 15). Nearer to home is the famous portrait of Becket in the stained glass of the north side of Trinity Chapel in Canterbury, immediately above Becket's shrine where his jewelled Psalter was probably sometimes displayed (Plate 2). There is uncertainty as to how much of this picture is a modern re-creation, and it may be of no value whatsoever to us that Thomas Becket is shown there cradling a book of the size of MS 411 in the Parker Library with some kind of decoration on its lower cover; but it may also be based on or is part of the lost original window of around 1200. Of course, holding a book was a conventional medieval symbol of saintliness (and Becket would have been aware of that too, and he knew the value of theatre). Late medieval pictures and alabasters of the martyrdom itself often show a book, on the altar, in Becket's hand or passed for safety to his attendant chaplain to hold together with his episcopal crosier (Plate 16). This too may simply be a convention of piety, or a book might later have been grafted into the iconography because the Psalter itself was already preserved and was by then probably exhibited by the cathedral sacristan to pilgrims as a relic of the martyr.

The biggest question, then, which is unanswerable, is whether Becket actually was holding the Psalter when he was killed. Nine contemporary biographies describe

the martyrdom, including four by witnesses who were actually present, and not one of them mentions a book, unless it was so obvious that it was unnoticed (a point made in other contexts by Sherlock Holmes). The whole event is closely documented. In the last hours of his life, Becket knows that it is all over. The four knights arrive noisily, clearly drunk, while the archbishop is at dinner. Thomas Becket then slips back to his bedchamber where he gathers up the regalia with which, by then, he knows he is about to die – his skull cap, his surplice, his dark cloak, his ring of office, and, it would be believable, his Psalter of Saint Alphege the martyr. He goes through the side door into the cathedral. Vespers was drawing to its close. The four knights thrust in behind him. They were Reginald FitzUrse, William de Tracey, Hugh de Morville and Richard le Breton. In the dusk they demanded, 'Where is Thomas Becket, traitor to king and country?' and Becket replied, 'Here I am, not traitor to the king, but a priest of God.' More insults were exchanged, and there was shouting, and Becket was struck down, and his skull was hacked open. Not all the narratives record what he said as he died, but two of them, including that of William FitzStephen, who was there, report that the archbishop's absolute last words spoken on Earth were to commend his soul into the care of Saint Alphege. That would explain why this particular book, a mere book, Alphege's Psalter, also became a relic of Thomas Becket.

Notes

My interest in manuscripts owned by Thomas Becket goes back to a thesis in Oxford in the early 1970s on glossed books of the Bible, of which Becket owned one of the earliest datable sets, and to the electrifying classes given then by William Urry, Becket master incomparable. From him I learned that 'à Becket' is a nineteenth-century misnomer, perhaps by back formation from Thomas Aquinas and Thomas à Kempis. The identification of Becket's Psalter would never have happened but for a chance discussion with Eyal Poleg, as recounted in the text. I have given several lectures on the Psalter, including one at the Society of Antiquaries in London (2017), of which a recording is available on-line, a Breslauer Lecture at the Grolier Club in New York that same year, and another as Henry King Stanford Visiting Professor in the Humanities at the University of Miami in 2018. I owe the idea for this little book to conversations with Richard Linenthal, Lloyd de Beer, Caroline Dawnay and Stuart Proffitt, and I am grateful for friendly cooperation from Philippa Hoskin, my successor as Fellow Librarian in the Parker Library.

The black-robed archimandrite with whom I began had just conducted my wedding and was taking us to lunch. We had a long and good marriage, and my wife died last summer; I dedicate this little book to her memory. There have been countless publications on the life and place in history of Thomas Becket since at least 1495, and there will be more in 2020, the 850th anniversary year of his martyrdom and the 800th of the shrine in Canterbury, including *Becket*, the catalogue (edited by Lloyd de Beer and Naomi Speakman) of an anniversary exhibition at the British Museum that will include the Psalter. I have especially used David Knowles, *Thomas Becket*, London, 1970; Beryl Smalley, *The Becket Conflict and the Schools: A Study of Intellectuals in Politics*, Oxford, 1973; Frank Barlow, *Thomas Becket*, London, 1986; and William Urry, *Thomas Becket: His Last Days*, edited by Peter A. Rowe, Stroud, 1999. The principal primary sources are still invaluably available in J. C. Robertson (and J. B. Sheppard for vol. VII), ed., *Materials for the History of Thomas Becket, Archbishop of Canterbury*, London (Rolls Series), seven volumes, 1875–85. For the cult, I read the essays of Anne

J. Duggan gathered in her *Thomas Becket: Friends, Networks, Texts and Cult*, Aldershot and Burlington, VT, 2007, and P. Webster and M.-P. Gelin, eds., *The Cult of St Thomas Becket in the Plantagenet World, c. 1170–c. 1220*, Woodbridge, 2016, esp. P. Webster, 'Introduction', pp. 1–24, A. J. Duggan, 'Becket is Dead! Long Live Saint Thomas', pp. 25–51, and M.-P. Gelin, 'The Cult of St Thomas in the Liturgy and Iconography of Christ Church, Canterbury', pp. 53–79. The visit by Erasmus in 1512 is published in J. G. Nichols, *Pilgrimage to Saint Mary of Walsingham and Saint Thomas of Canterbury by Desiderius Erasmus, Newly Translated*, Westminster, 1849, esp. pp. 47 and 49–59, and cited also in John Butler, *The Quest for Becket's Bones: The Mystery of the Relics of St Thomas Becket of Canterbury*, New Haven and London, 1995, pp. 31–2. For the early nineteenth-century interest in autographs, see A. N. L. Munby, *The Cult of the Autograph Letter in England*, London, 1962. On the elusiveness of Becket's personality and even uncertain saintliness, described on p. 7, see especially David Knowles, *Archbishop Thomas Becket: A Character Study*, London (Proceedings of the British Academy, 35), 1950; and also Paul Binski, *Becket's Crown: Art and Imagination in Gothic England, 1170–1300*, New Haven and London, 2004, pp. 40–41. The best account of Becket's *eruditi* in exile must still be Smalley, cited above, especially Chapter III on Herbert of Bosham, pp. 59–86, and Chapter IV on John of Salisbury, pp. 87–108, and for Herbert now Michael Staunton, ed., *Herbert of Bosham: A Medieval Polymath*, Woodbridge and Rochester, NY, 2019. Herbert's description of Pontigny as a pastureland is in his edition of Peter Lombard, now Trinity College, Cambridge, B.5.4 (M. R. James, *The Western Manuscripts in the Library of Trinity College, Cambridge*, I, Cambridge, 1900, p. 189). The twelfth-century Pontigny library catalogue is printed in Monique Peyrafort-Huin, *La Bibliothèque médiévale de l'abbaye de Pontigny (XII^e–XIX^e siècles): Histoire, inventaires anciens, manuscrits*, Paris (Documents, études et répertoires, Institut de Recherche et d'Histoire des Textes, 60), 2001, pp. 245–85. The texts on Becket's commissioning a library in France are in C. R. Dodwell, *The Canterbury School of Illumination, 1066–1200*, Cambridge, 1954, pp. 106–9, and elsewhere. For the library of William of Saint-Calais, see my own *Meetings with Remarkable Manuscripts*, London, 2016, pp. 262–7, with references. Becket's reported statement on the bringing of his library to Canterbury, quoted here on pp. 10–11, has

often been published in Latin, including by Dodwell, p. 108, and on p. 67, n. 14, of Laura Cleaver, 'Pages Covered with as Many Tears as Notes: Herbert of Bosham and the Glossed Manuscripts for Thomas Becket', pp. 64–86 in Staunton, *Herbert of Bosham*, but nowhere, to my knowledge, fully translated. I am grateful to Rodney Thomson and, through him, Michael Winterbottom, for disentangling its elusive syntax.

For simplicity's sake, I refer throughout to Canterbury Cathedral or to the cathedral priory, without its correct but maybe confusing medieval name of Christ Church. It was one of the uniquely English cathedrals staffed by Benedictine monks. The fourteenth-century library catalogue is published in M. R. James, *The Ancient Libraries of Canterbury and Dover*, Cambridge, 1903, Becket's books being pp. 82–5, nos. 783–853. A new edition by J. M. W. Willoughby with the parallel inventories of Canterbury College, Oxford, edited by R. Sharpe, is promised for the Corpus of British Medieval Library Catalogues. There is discussion of the list of Becket's books in Smalley, *The Becket Conflict*, pp. 135–7, my own *Glossed Books of the Bible and the Origins of the Paris Booktrade*, Woodbridge and Dover, NH, 1984, pp. 38–47, and Cleaver, 'Pages', pp. 67–9. The Pontigny copies of Peter of Ravenna and Guerric of Igny are p. 279, nos. 174–5, in Peyrafort-Huin. Becket's Odo of Morimond is Trinity College, Cambridge, B.16.17 (James, *Western Manuscripts*, I, pp. 526–7, no. 391; it is digitized in the Wren Digital Library). The Solinus with Valerius Maximus at Pontigny, cited here on p. 15, is no. 170, p. 278, in Peyrafort-Huin. John of Salisbury's copy is listed in C. Webb, 'Note on Books Bequeathed by John of Salisbury to the Cathedral Library at Chartres', *Medieval and Renaissance Studies*, I, 1941–3, pp. 128–9. The Pontigny Cassiodorus is p. 264, no. 102, in Peyrafort-Huin. Becket's copy is Magdalen College, Oxford, MS lat. 166; it is the subject of a blog on the college's website *Illuminating Magdalen*, 'A Book from Thomas à Becket's Library', 30 November 2015. There is more to be discovered about the sharing of exemplars by John of Salisbury and Herbert of Bosham with the contemporaneous private library of Henry the Liberal (1127–81), count of Champagne, who also acquired texts of Livy, Frontinus, Aulus Gellius and Valerius Maximus, among others, at least two of them copied by an English scribe, Wilelmus, in 1167 and 1170 (A. J. Duggan, 'Classical Quotations and Allusions in the Correspondence of Thomas Becket, An Investigation of their Sources', *Viator*, 23,

2001, pp. 1–22, reprinted in her *Thomas Becket*, as above, 2007, no. IV, esp. pp. 7–8; and Patricia Stirnemann in T. Delcourt, ed., *Splendeurs de la cour de Champagne au temps de Chrétien de Troyes, Catalogue de l'exposition*, Troyes, 1999, p. 40 and nos. 28–30, and Stirnemann, 'Private Libraries Privately Made', pp. 185–98 in *Medieval Manuscripts, Their Makers and Users: A Special Issue of Viator in Honor of Richard and Mary Rouse*, Turnhout, 2011, esp. p. 189, with further references). For John of Salisbury's use of Livy, see Irene O'Daly, *John of Salisbury and the Medieval Roman Renaissance*, Manchester, 2018, pp. 107–8, which cites Janet Martin, 'John of Salisbury as a Classical Scholar', pp, 179–202 in M. Wilks, ed., *The World of John of Salisbury*, Oxford, 1984, p. 185. The second volume of Becket's Livy is Trinity College, Cambridge, R.4.4 (James, *Western Manuscripts*, II, 1901, pp. 132–3, no. 637, digitized in the Wren Digital Library; it is cited by L. D. Reynolds in Reynolds, ed., *Texts and Transmission, A Survey of the Latin Classics*, Oxford, 1983, p. 209; and for its similarity to the manuscripts made in Champagne for Henry the Liberal, see P. Binski and P. Zutshi, *Western Illuminated Manuscripts: A Catalogue of the Collection in Cambridge University Library*, Cambridge, 2011, p. 277). Becket's copy of the *Polycraticus* is Corpus Christi College, Cambridge, MS 46 (M. R. James, *Descriptive Catalogue of the Manuscripts in the Library of Corpus Christi College*, I, 1912, pp. 92–3, digitized in Parker on the Web). Becket's glossed Pentateuch is Bodleian, MS Auct. E.inf.7 (O. Pächt and J. J. G. Alexander, *Illuminated Manuscripts in the Bodleian Library, Oxford,* III, Oxford, 1973, p. 22, no. 200); his Minor Prophets and Gospels are Trinity College, Cambridge, B.3.11 and B.5.5 (James, *Western Manuscripts*, I, pp. 111–12, no. 90, and 194–5, no. 151, digitized in the Wren Digital Library; D. Jackson, N. Morgan and S. Panayotova, *A Catalogue of Western Book Illumination in the Fitzwilliam Museum and the Cambridge Colleges*, III, i, London and Turnhout, 2015, pp. 90–92, no. 27, and pp. 98–102, no. 31). Trinity College, B.4.30 may be Becket's copy of Kings glossed, except that Becket's also contained Chronicles, which this does not. Trinity College B.3.12, Joshua and other glossed texts, is also often said to have been Becket's (no. 786 in the list), except that it *does* contain Chronicles. Confusion or rebinding are possible. The Minor Prophets volume is signed by the scribe Roger of Canterbury, who probably also copied the Pentateuch; the Kings is signed by the scribe

'Guilelmus Tuncat Leonem', 'lion-chopper', perhaps Tranchelion from south-west of Tours. The picture of the archbishop is in the volume of the Gospels, folio 130v. In my *Glossed Books of the Bible*, which discusses these books in detail, I probably over-emphasized a probable origin in Paris: Sens now seems to me as likely. Some of Becket's law books are identified in H. Kantorowicz with W. W. Buckland, *Studies in the Glossators of the Roman Law: Newly Discovered Writings of the Twelfth Century*, Cambridge, 1938, reprinted Aalen, 1969, p. 30. John of Salisbury's relics of Becket, mentioned on p. 20, are described in K. Bollermann and C. J. Nederman, 'A Special Collection: John of Salisbury's Relics of Saint Thomas Becket and Other Holy Martyrs', *Mediaevistik*, 26, 2013, pp. 163–81. Herbert's reference to himself as a living relic is cited most recently by M. Staunton on p. 11 of 'Introduction to Herbert of Bosham', pp. 1–28 of his *Herbert of Bosham*. The miracle of the Saint Cuthbert Gospel is recounted in Richard Gameson, 'History of the Manuscript to the Reformation', pp. 129–36 in C. Breay and B. Meehan, eds., *The St Cuthbert Gospel, Studies on the Insular Manuscript of the Gospel of John (BL, Additional MS 89000)*, London, 2015, p. 132. For Saint Boniface's sword-gashed manuscript, see Lutz E. von Padberg, *Studien zur Bonifatiusverehrung: Zur Geschichte des Codex Ragyndrudis und der Fuldaer Reliquien des Bonifatius*, Frankfurt am Main (Fuldaer Hochschulschriften, 25), 1996, esp. pp. 24–44. The relic status of both these manuscripts has preserved for us the two earliest European book bindings. For Becket's law books listed in Oxford in the inventory of 1524, see James, *Ancient Libraries*, p. 171, nos. 261, 'Digestum novum sancti Thome martiris', and 263, 'Vetus digestum S. Thome', corresponding to nos. 839–40 in the booklist. For the Aulus Gellius that was probably Becket's, see A. C. de la Mare, 'Pietro de Montagnana and the Text of Aulus Gellius', pp. 219–25 in *Scriptorium*, 30, 1976, esp. pp. 223–4. The manuscript is now Paris, Bibliothèque nationale de France, ms lat. 13038. David Rundle suggested to me the possibility that it was taken to Padua by John Tiptoft. The Eadwine or Canterbury Psalter is Trinity College, Cambridge, R.17.1; the likelihood of Becket having been its patron is presented by Margaret Gibson, 'Conclusions: The Eadwine Psalter in Context', pp. 209–13 in M. Gibson, T. A. Heslop and R. W. Pfaff, eds., *The Eadwine Psalter: Text, Image, and Monastic Culture in Twelfth-Century Canterbury*, London and University Park PA, 1992, pp. 211–12.

The relics listed on pp. 22–3 here are taken from J. Wickham Legg and W. H. St John Hope, eds., *Inventories of Christchurch Canterbury, with Historical and Topographical Introductions and Illustrative Documents*, Westminster, 1902, pp. 85–6. Lloyd de Beer tells me that the Sens relics are not recorded before 1496 and may be early thirteenth century. The vestments of Courtrai and Arras are described in *Thomas Becket in Vlaanderen: Waarheid of legende?*, exhibition catalogue, Stedelijke Musea Kortrijk, 2000, esp. articles by Isabelle De Jaegere, Marie Mones y Casanova and Daniël De Jonghe, pp. 122–55, and pp. 158–9, no. 1.1, and 162, no. 1.6. For the chasuble in Fermo, see A. Shalem, ed., *The Chasuble of Thomas Becket, A Biography*, Chicago, 2018. The relic from the Vatican was to be lent to Canterbury Cathedral in 2020.

Eyal Poleg is senior lecturer in material history at Queen Mary University, London. He cites the entry on Becket's Psalter in his *Approaching the Bible in Medieval England*, Manchester, 2013, p. 71. It was first published in John Dart, *The History and Antiquities of the Cathedral Church of Canterbury, and the Once-Adjoining Monastery*, London, 1726, Appendix, p. xvii, and in A. Welby Pugin, *Glossary of Ecclesiastical Ornament and Costume*, London, 1844, p. 206, in Pugin's definition of 'text', but the best source is Wickham Legg and St John Hope, 1902, as above, p. 79. MS 411 in the Parker Library is principally described in James, *Descriptive Catalogue*, II, 1912, pp. 296–8; E. Temple, *Anglo-Saxon Manuscripts, 900–1066*, London (A Survey of Manuscripts Illuminated in the British Isles, 2), 1976, pp. 63–4, no. 40; Mildred Budny, *Insular, Anglo-Saxon, and Early Anglo-Norman Manuscript Art at Corpus Christi College, Cambridge: An Illustrated Catalogue*, Kalamazoo and Cambridge, 1997, pp. 253–63, no. 22; T. Webber in P. Binski and S. Panayotova, eds., *The Cambridge Illuminations: Ten Centuries of Book Production in the Medieval West*, London and Turnhout, 2005, pp. 72–3, no. 18; and N. Morgan and S. Panayotova with R. Rushforth, *Catalogue of Western Book Illumination*, as above, IV, i, 2013, pp. 75–7, no. 25; it is digitized on Parker on the Web. On p. 25, I mention the 'old inscription': in addition to a missing leaf, there is also a possible erasure in the upper margin of the opening page of text, which M. R. James read as beginning 'psalterium' but I cannot see at all. The main account of Matthew Parker as a collector is still R. I. Page, *Matthew Parker and his Books*, Kalamazoo, 1990, but there has been recent work by Scott

Mandelbrote, Anthony Grafton, and others. For Parker's injunctions for Canterbury, cited here on pp. 26–7, see W. H. Frere, ed., *Visitation Articles and Injunctions of the Period of the Reformation*, III, London, 1910, p. 79. Parker's history is *De Antiquitate Britannicae Ecclesiae & Privilegiis Ecclesiae Cantuariensis cum Archiepiscopis eiusdem*, London (perhaps actually in Lambeth Palace), 1572; I have the edition of Hanover, 1605, in which the life of Becket is on pp. 128–38. The manuscripts of Gandison's life of Becket, which is still unpublished, are Corpus MSS 275, 464 and 467. The Middle English text is by Laurence Wade, MS 298. There is much on the development of private Psalters in F. O. Büttner, ed., *The Illuminated Psalter: Studies in the Content, Purpose and Placement of its Images*, Turnhout, 2004. At some point here I should add that Jean, duc de Berry (1340–1416), also owned a Psalter which was said to have belonged to Becket, described in 1401 as being old, having a calendar and many miniatures, and being bound in purple velvet (J. Guiffrey, *Inventaires de Jean, duc de Berry 1401–1416*, I, Paris, 1894, p. 231, no. 882); it is not known to survive and the attribution is unlikely. The identification of the scribe of MS 411, cited here on p. 30, was made by T. A. M. Bishop, 'Notes on Cambridge Manuscripts, II', pp. 185–92 in *Transactions of the Cambridge Bibliographical Society*, 2, 1954–58, p. 187. The manuscript's frontispiece now has added initials in the lower margin, 'W. S.', not easily explicable: not those of the artist (and the drawing is not a post-medieval fake), possibly an eighteenth-century admirer, conceivably William Stanley (1647–1731, master of Corpus) or William Stukeley (1687–1765, college antiquary). On the use of Egyptian blue in MS 411, see S. Panayotova and S. Ricciardi, 'Painting the Trinity Hrabanus: Materials, Techniques and Methods of Production', pp. 227–49 in *Transactions of the Cambridge Bibliographical Society*, 16, 2017, esp. pp. 241–5, and A. Beeby, R. Gameson and C. Nicholson, 'Colour at Canterbury: The Pigments of Canterbury Illuminators from the Tenth to Twelfth Centuries', pp. 21–35 in S. Panayotova and P. Ricciardi, eds., *Manuscripts in the Making: Art and Science*, London and Turnhout, 2017. The volume which includes the Canterbury inventories as well as the library catalogue is British Library, Cotton MS Galba E.IV. The sacrist's list of 1321 is printed in Wickham Legg and St John Hope, pp. 78–94. For Prior Eastry and his inventories, see B. Dobson, 'The Monks of Canterbury in the Later Middle Ages, 1220–1540', pp. 68–153 in P. Collinson, N. Ramsay

and M. Sparks, eds., *A History of Canterbury Cathedral*, Oxford, 1995, esp. pp. 84–99, and N. Ramsay, 'The Cathedral Archives and Library', pp. 341–407 in *ibid.*, esp. pp. 353–62. I supplied dates for the monks mentioned from Joan Greatrex, *Biographical Register of the English Cathedral Priories of the Province of Canterbury, c. 1066–1540*, Oxford, 1997. The definition of *'textus'* on pp. 32–3 here derives mainly from Chapter 2, 'The Bible as Talisman: *Textus* and Oath-Books', pp. 59–107 in Poleg, *Approaching the Bible*, as above, with further examples. The word *textus* is a fourth declension noun, and so the plural is *textus* too, but with a long 'u' when pronounced, like *domus*. A good account of treasure bindings is in Paul Needham, *Twelve Centuries of Bookbindings, 400–1600*, New York and London, 1979, pp. 21–54; the manuscripts of Judith of Flanders are Morgan M 708 and 709. Needham provisionally attributed the bindings to England, but they are now thought to be possibly Flemish or German (C. Breay and J. Story, eds., *Anglo-Saxon Kingdoms: Art, Word, War*, London, 2018, pp. 340–41, no. 136). The Gospel Book of Countess Godgifu (or Goda) is British Library, Royal MS I.D.III; the medieval description of its former binding is published in J. Thorpe, *Registrum Roffense, or a Collection of Antient Records, Charters, and Instruments of Divers Kinds*, London, 1759, p. 119. The letter to Richard of St-Victor about Limoges book covers is cited in (among other places) Barbara Drake Boehm, *'Opus Lemovicense*: The Taste for and Diffusion of Limousin Enamels', pp. 40–47 in J. P. O'Neill, ed., *Enamels of Limoges, 1100–1350*, New York, 1996, p. 40. The British Museum ivory of Christ in Majesty is 1991, 0401.1 (P. Lasko, *Ars Sacra, 800–1200*, New Haven and London, 1994, p. 75, pl. 109); there is a slightly larger and more refined Anglo-Saxon ivory of the same subject and date in the Victoria and Albert Museum, A.32-1928, but it is more than three quarters of an inch deep and it may be too thick for use on a binding, according to Paul Williamson, *Medieval Ivory Carvings*, London, 1982, p. 32. On the Psalter's additional litany and its connection with the relics of Abingdon (p. 37 here), see M. Lapidge, *Anglo-Saxon Litanies of the Saints*, London, 1991 (Henry Bradshaw Society, CVI), pp. 65–6, no. VII, and 120–24. The *Vita S. Alphegi* of Osbern is printed in H. Wharton, *Anglia Sacra, sive Collectio Historiarum . . . de Archiepiscopis & Episcopis Angliae*, II, London, 1691, pp. 122–47, describing Alphege's use of the psalms in captivity on p. 140 and his standing

barefoot to pray on p. 127. The characteristic prickly script of early Norman Canterbury was defined in N. R. Ker, *English Manuscripts in the Century after the Norman Conquest: The Lyell Lectures, Oxford, 1952–3*, Oxford, 1960, pp. 25–32. I owe to Anne Duggan the reference to Herbert's mission to collect Becket's manuscript from Canterbury: it is Robertson, *Materials*, III, 1877, p. 313. John of Salisbury's advice to Becket on p. 40 is letter 144 in W. J. Millor and C. N. L. Brooke, *The Letters of John of Salisbury*, II, *The Later Letters (1163–80)*, Oxford, 1979, pp. 34–5. The archbishop's study of the Psalms at Pontigny and the comparisons with King David are Robertson, *Materials*, III, 1877, pp. 359, 205 and 320–21. The letter 'Expectans expectavi' is addressed to Henry II: Robertson, *Materials*, V, 1881, pp. 269–78, cited by Knowles, *Becket*, p. 112, and elsewhere. For the psalm quotations on p. 41, I have used the numbering of the Latin Vulgate (which would be psalms 146, 110 and 52 in the modern English Bible) and the wording of the Rheims-Douai translation taken from the Vulgate. The Winchester Bible is in Winchester Cathedral, MS 17, and psalm 51 is on fol. 232r; for the association of the subject with the murder of Becket, see Walter Oakeshott, *The Two Winchester Bibles*, Oxford, 1981, p. 113, which credits me and so is ultimately circular evidence, and Claire Donovan, *The Winchester Bible*, London and Winchester, 1993, p. 50. For medieval pictures of Becket, see T. Borenius, *St Thomas Becket in Art*, London, 1933, and P. A. Newton, 'Some New Material for the Study of the Iconography of St Thomas Becket', pp. 255–63 in R. Foreville, ed., *Thomas Becket, Actes du colloque international de Sédières, 19–24 août 1973*, Paris, 1975. The most vivid and scholarly modern narrative of the murder is Urry, *Last Days*. The two contemporary lives which mention Saint Alphege by name as Becket's final invocation are those of William FitzStephen, who was there, and the so-called Roger of Pontigny (Robertson, *Materials*, III, 1877, p. 141, and IV, 1879, p. 77); William of Canterbury says 'patrons of this church' without a name (*Materials*, I, 1875, p. 133). If Alphege was invoked, his Psalter was in effect the last item used on Earth by Thomas Beckett.

List of Illustrations

Index of People

Ælfheah *see* Alphege

Ælfric, *archbishop* (d. 1005) 36–7

Alfred, *king* (c. 847/49–899) 7

Alphege, *archbishop, saint* (c. 953/54–1012) 37–9, 42, 44, 52–3

Anouilh, Jean (1910–1987) 8

Anselm, *archbishop, saint* (c. 1033/34–1109) 7, 20

Anselm of Laon (d. 1117) 19

Aquinas, Thomas, *saint* (1225–1274) 45

Augustine of Canterbury, *archbishop, saint* (d. 604) 20, 27, 30

Augustine of Hippo, *saint* (354–430) 19

Aulus Gellius (c. 125–c. 180) 15, 22, 47, 49

Austen, Jane (1775–1817) 6

Beatles, The 6

Becket, Thomas, archbishop, saint (c. 1118/19–1170) *passim*

Bede, saint (c. 672/73–735) 7, 19, 20

Benedict, saint (c. 480–c. 543) 37

Bernard of Clairvaux, saint (1090–1153) 13

Boniface, saint (c. 672/5–754) 21, 39, 49

Boethius, Anicius Manlius Severinus (c. 480–524) 30

Brontë sisters 6

Budny, Mildred 36

Byron, George Gordon, baron (1788–1824) 5

Cassiodorus (c. 490–c. 583) 15–16, 47

Cicero, Marcus Tullius (106–43 BC) 15

Colet, John (1467–1519) 4

Cranmer, Thomas, archbishop (1489–1556) 27

Cuthbert, saint (c. 634–687) 20–21

David, king (eleventh to tenth century BC) 28, 30, 38, 41, 53

Dawnay, Caroline 45

de Beer, Lloyd 45

Denis, chaplain (fourteenth century) 32

Doeg, high priest (eleventh century BC) 41

Duggan, Anne 53

Dunstan, archbishop, saint (909–988) 20

Edmund, earl of Cornwall (1249–1300) 34

Eliot, Thomas Stearns (1888–1965) 8

Elizabeth I, queen (1533–1603) 26

Erasmus, Desiderius (1466–1536) 4–5, 46

Eustace, saint (second century) 37

55

Index of Manuscripts